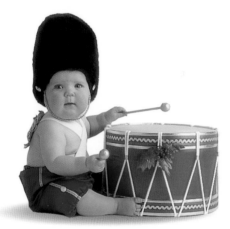

ISBN 1-55912-003-7

© Anne Geddes 1994

Published in 1995 by Cedco Publishing Company,
2955 Kerner Blvd, San Rafael, CA 94901.
First USA edition 1995.
Second printing, June 1995

Props and styling by Dawn McGowan
Designed by Jane Seabrook
Produced by Kel Geddes
Color separations by HQ Imaging
Artwork by Bass 'n' Else
Printed through Colorcraft, Hong Kong

The Twelve Days of Christmas

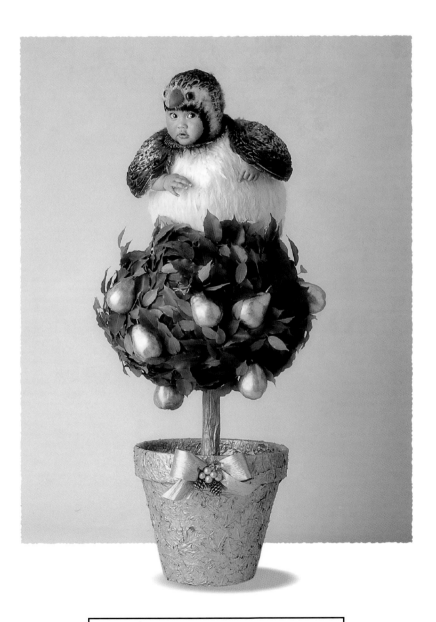

ANNE GEDDES

On the first day of Christmas,
My true love gave to me,

A partridge in a pear tree.

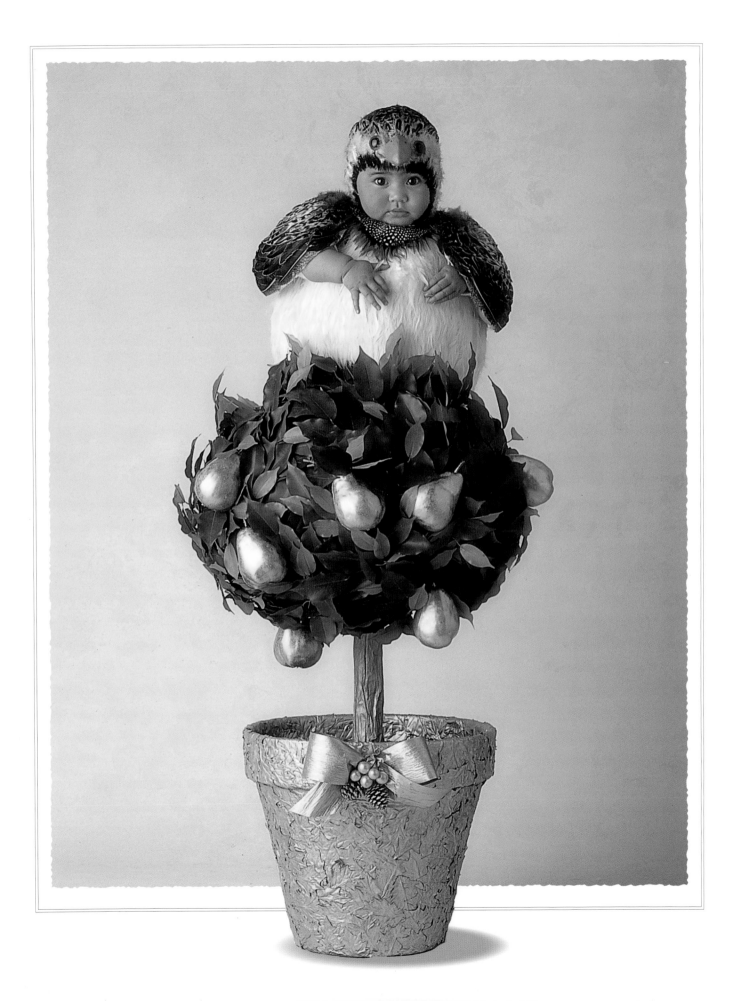

On the second day of Christmas,
My true love gave to me,

Two turtledoves,
And a partridge in a pear tree.

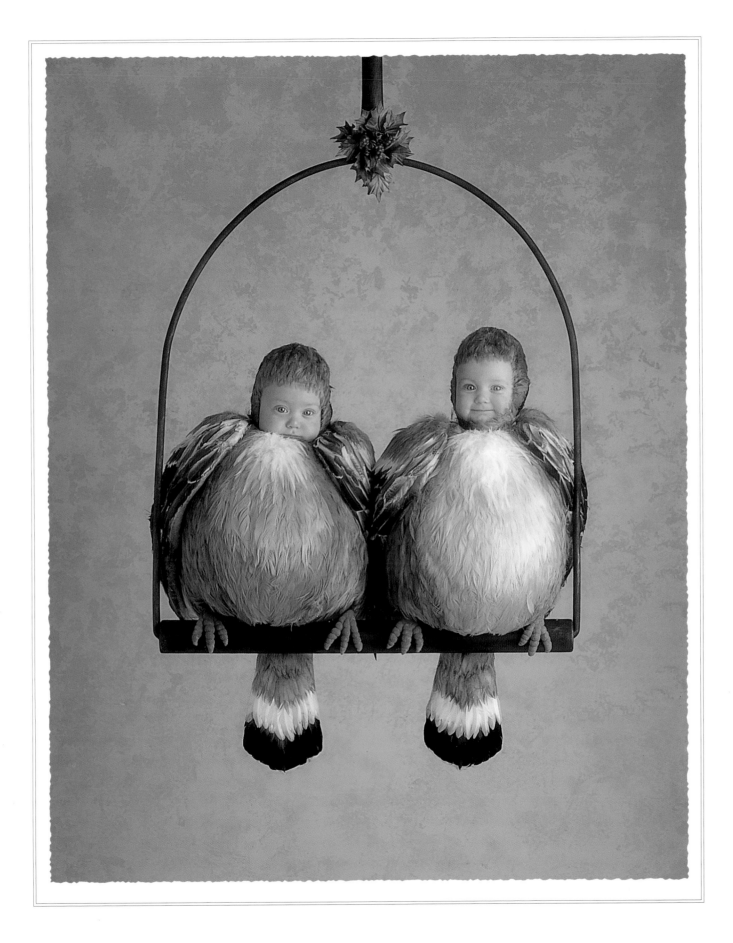

On the third day of Christmas,
My true love gave to me,

Three French hens,
Two turtledoves,
And a partridge in a pear tree.

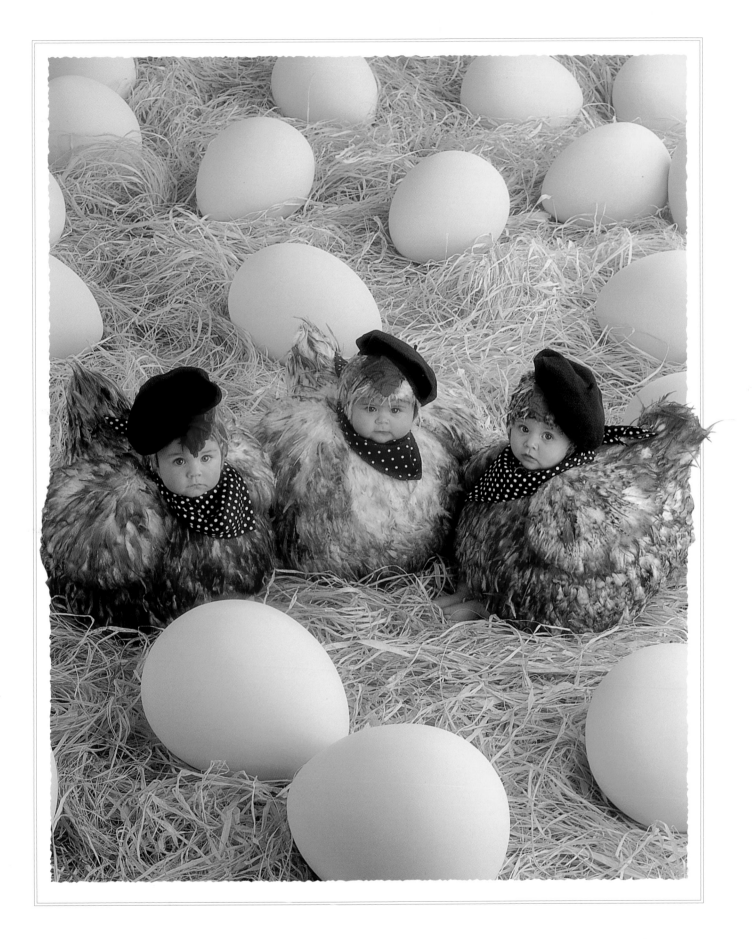

On the fourth day of Christmas,
My true love gave to me,

Four calling birds,
Three French hens,
Two turtledoves,
And a partridge in a pear tree.

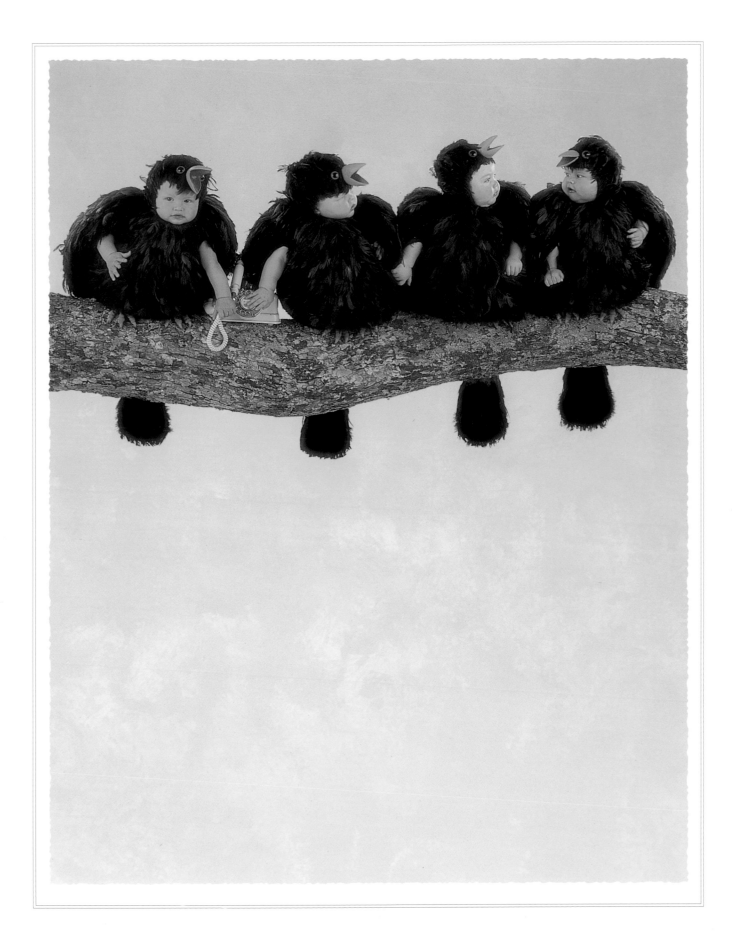

On the fifth day of Christmas,
My true love gave to me,

Five gold rings,
Four calling birds,
Three French hens,
Two turtledoves,
And a partridge in a pear tree.

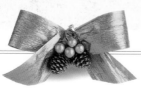

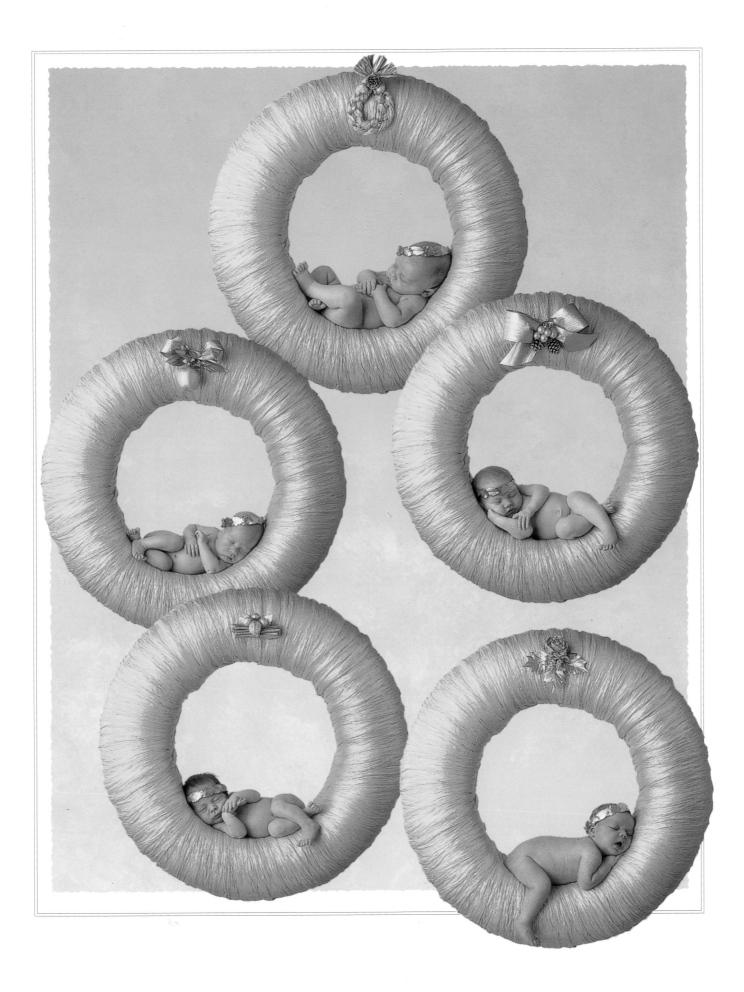

On the sixth day of Christmas,
My true love gave to me,

Six geese a-laying,
Five gold rings,
Four calling birds,
Three French hens,
Two turtledoves,
And a partridge in a pear tree.

On the seventh day of Christmas,
My true love gave to me,

Seven swans a-swimming,
Six geese a-laying,
Five gold rings,
Four calling birds,
Three French hens,
Two turtledoves,
And a partridge in a pear tree.

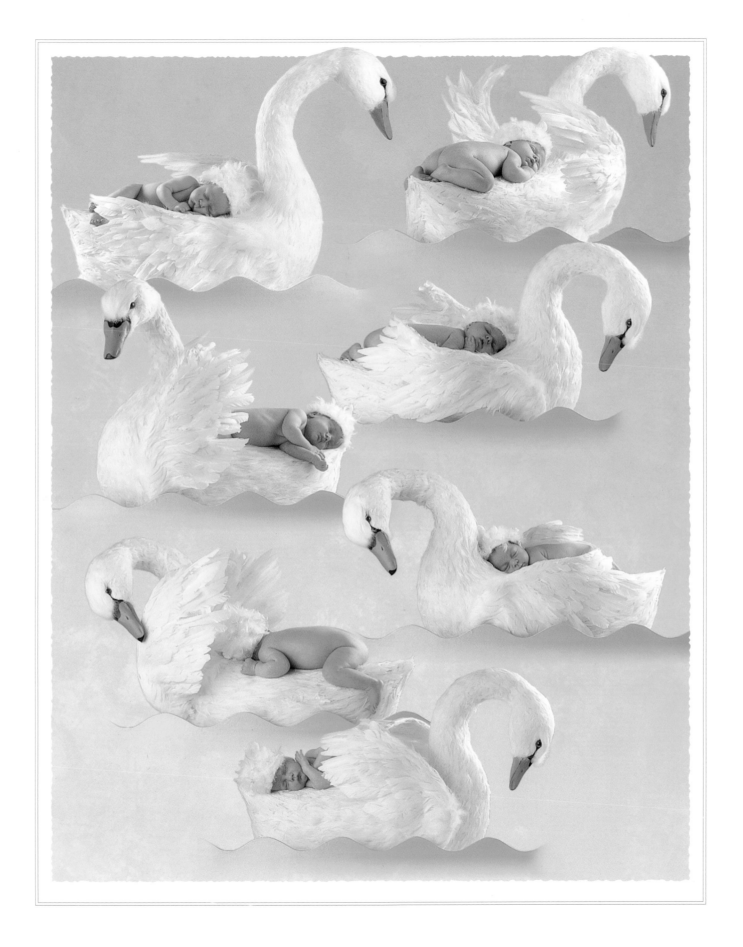

On the eighth day of Christmas,
My true love gave to me,

Eight maids a-milking,
Seven swans a-swimming,
Six geese a-laying,
Five gold rings,
Four calling birds,
Three French hens,
Two turtledoves,
And a partridge in a pear tree.

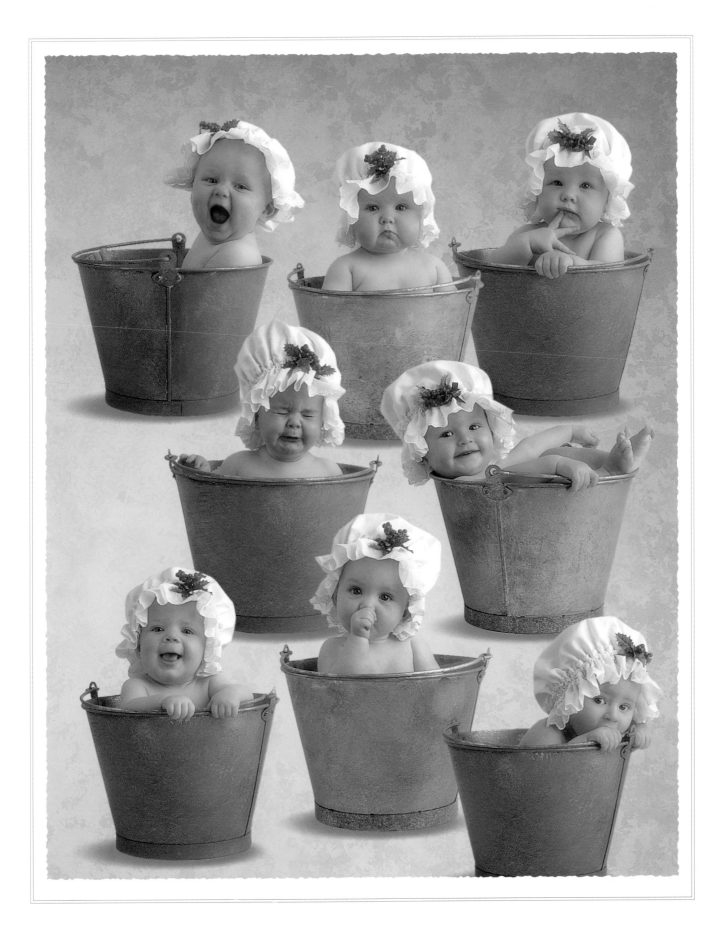

On the ninth day of Christmas,
My true love gave to me,

Nine ladies dancing,
Eight maids a-milking,
Seven swans a-swimming,
Six geese a-laying,
Five gold rings,
Four calling birds,
Three French hens,
Two turtledoves,
And a partridge in a pear tree.

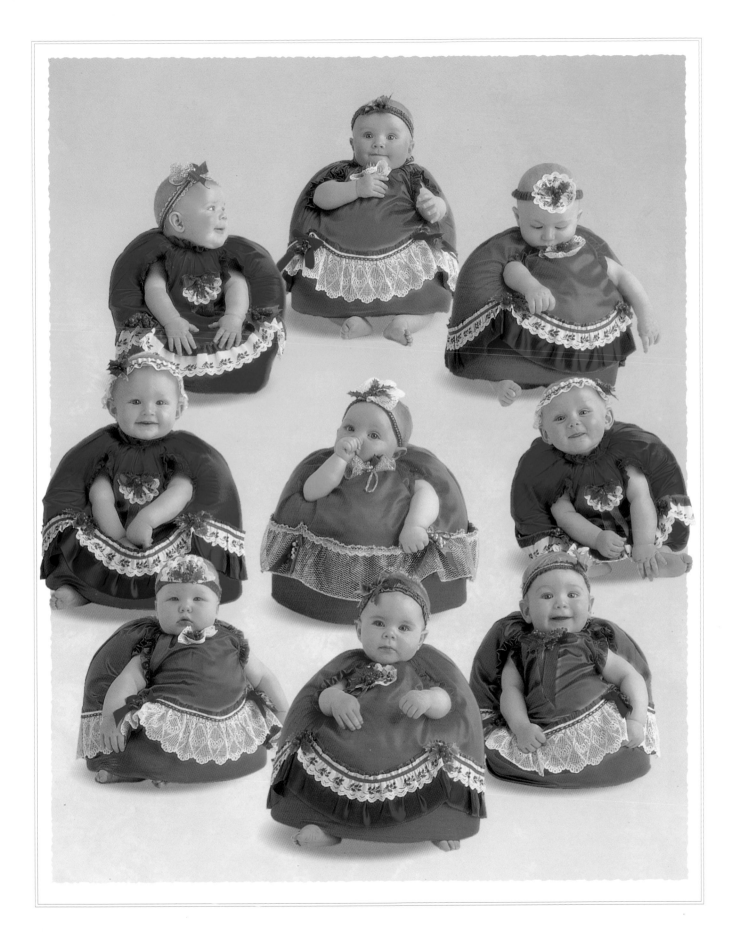

On the tenth day of Christmas,
My true love gave to me,

Ten lords a-leaping,
Nine ladies dancing,
Eight maids a-milking,
Seven swans a-swimming,
Six geese a-laying,
Five gold rings,
Four calling birds,
Three French hens,
Two turtledoves,
And a partridge in a pear tree.

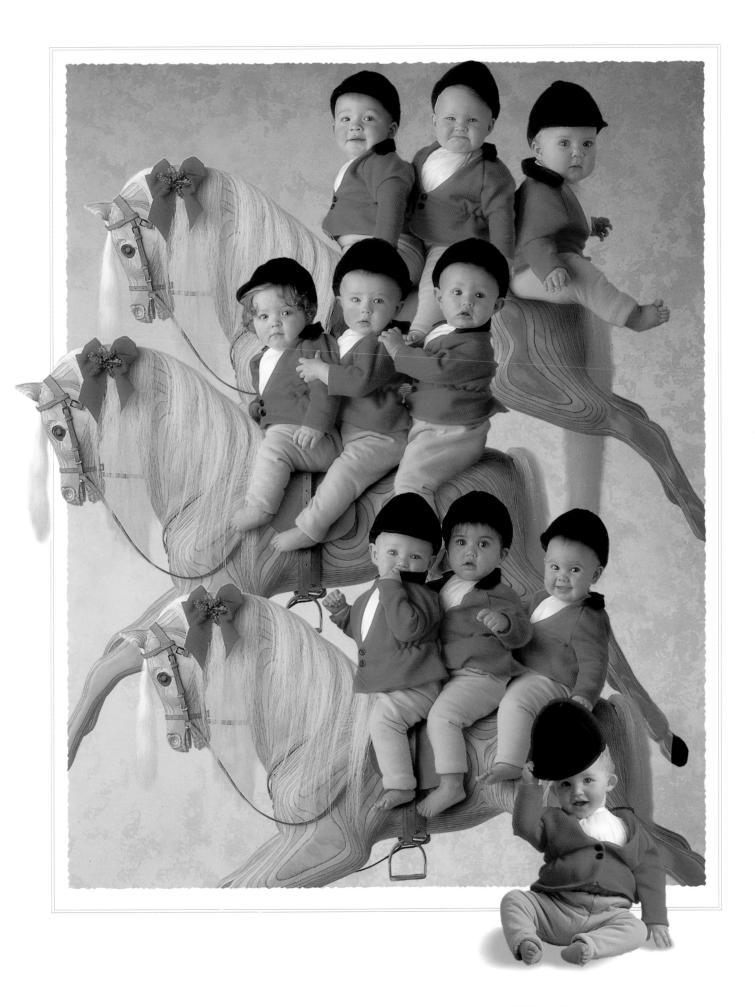

On the eleventh day of Christmas,
My true love gave to me,

Eleven pipers piping,
Ten lords a-leaping,
Nine ladies dancing,
Eight maids a-milking,
Seven swans a-swimming,
Six geese a-laying,
Five gold rings,
Four calling birds,
Three French hens,
Two turtledoves,
And a partridge in a pear tree.

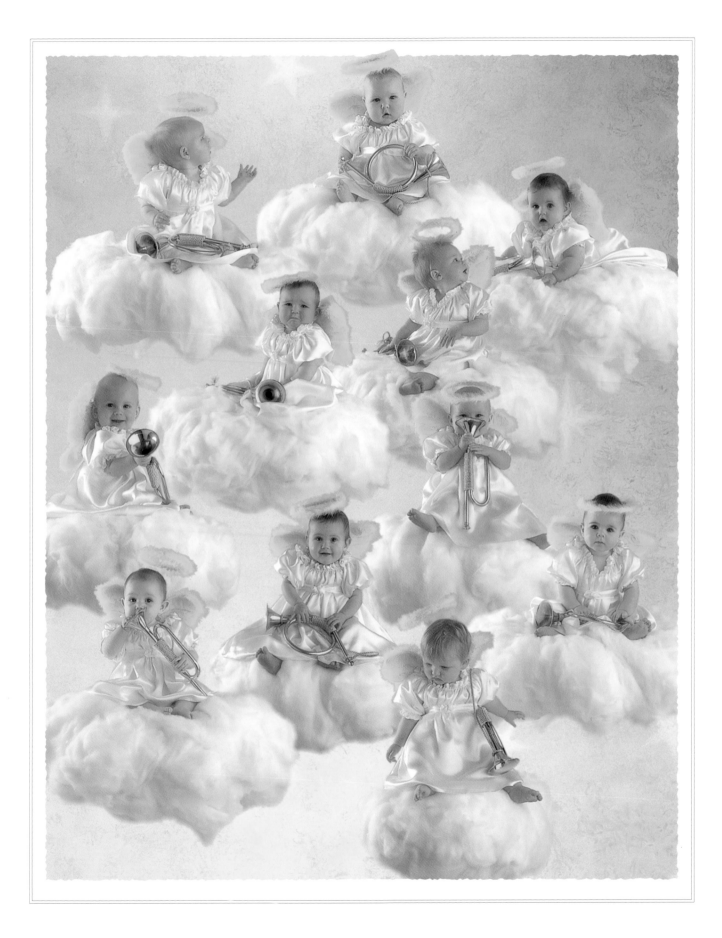

On the twelfth day of Christmas,
My true love gave to me,

Twelve drummers drumming,
Eleven pipers piping,
Ten lords a-leaping,
Nine ladies dancing,
Eight maids a-milking,
Seven swans a-swimming,
Six geese a-laying,
Five gold rings,
Four calling birds,
Three French hens,
Two turtledoves,
And a partridge in a pear tree.

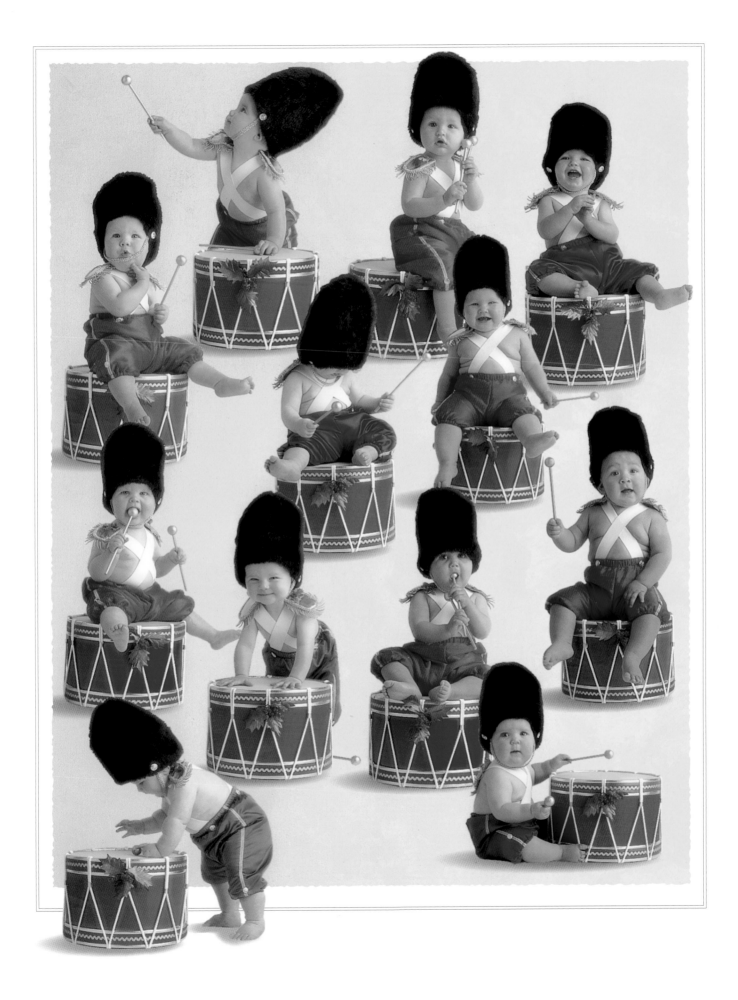

On the twelfth day of Christmas,
My true love gave to me,

Twelve drummers drumming,

Eleven pipers piping,

Ten lords a-leaping,

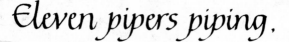

Nine ladies dancing,

Eight maids a-milking,

Seven swans a-swimming,

Six geese a-laying,

Five gold rings,

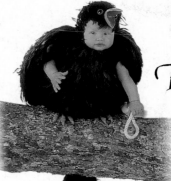

Four calling birds,

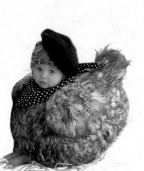

Three French hens,

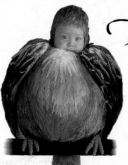

Two turtledoves,

And a partridge

in a pear tree.

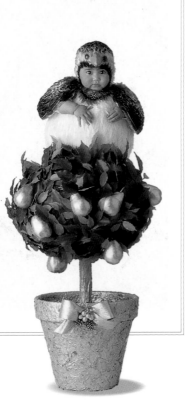

The Twelve Days of Christmas

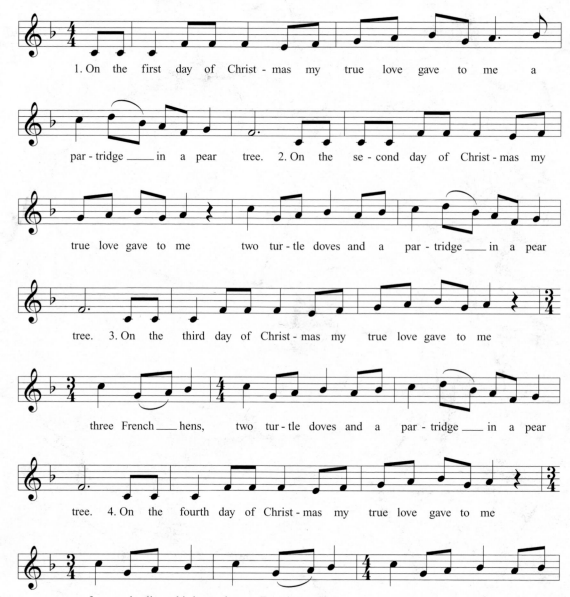

1. On the first day of Christ-mas my true love gave to me a par-tridge ___ in a pear tree. 2. On the se-cond day of Christ-mas my true love gave to me two tur-tle doves and a par-tridge ___ in a pear tree. 3. On the third day of Christ-mas my true love gave to me three French ___ hens, two tur-tle doves and a par-tridge ___ in a pear tree. 4. On the fourth day of Christ-mas my true love gave to me four cal-ling birds, three French ___ hens two tur-tle doves and a

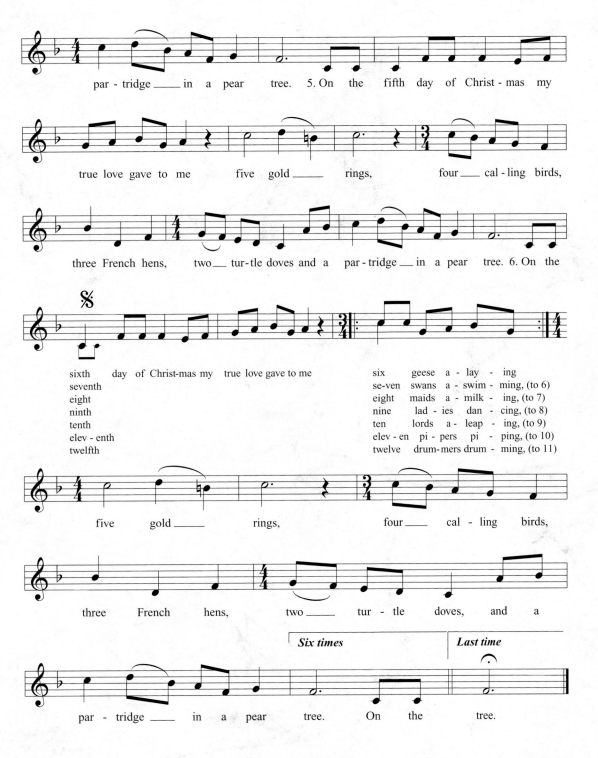

par - tridge ____ in a pear tree. 5. On the fifth day of Christ - mas my

true love gave to me five gold ____ rings, four ____ cal - ling birds,

three French hens, two ____ tur - tle doves and a par - tridge ____ in a pear tree. 6. On the

sixth	day of Christ-mas my true love gave to me	six geese a - lay - ing
seventh		se-ven swans a - swim - ming, (to 6)
eight		eight maids a - milk - ing, (to 7)
ninth		nine lad - ies dan - cing, (to 8)
tenth		ten lords a - leap - ing, (to 9)
elev - enth		elev - en pi - pers pi - ping, (to 10)
twelfth		twelve drum-mers drum - ming, (to 11)

five gold ____ rings, four ____ cal - ling birds,

three French hens, two ____ tur - tle doves, and a

Six times *Last time*

par - tridge ____ in a pear tree. On the tree.

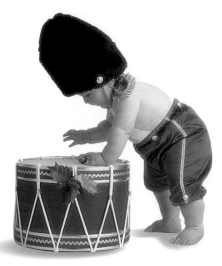